The Lewis Chessmen
Unmasked

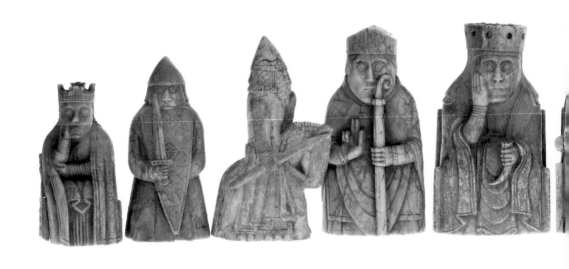

The Lewis Chessmen
Unmasked

DAVID H. CALDWELL

MARK A. HALL

CAROLINE M. WILKINSON

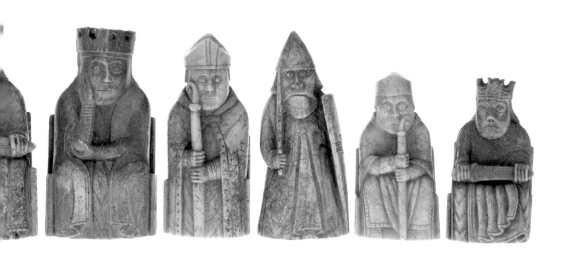

National Museums Scotland

Originally published in 2010 by
NMS Enterprises Limited – Publishing
a division of NMS Enterprises Limited
National Museums Scotland
Chambers Street, Edinburgh EH1 1JF
www.nms.ac.uk

Reprinted in 2010 and 2011 (twice) and 2012.

The moral rights of David H. Caldwell, Mark A.
Hall and Caroline M. Wilkinson to be identified
as the authors of this book have been asserted
by them in accordance with the Copyright,
Designs and Patents Act 1988.

British Library Cataloguing in Publication Data
A catalogue record for this book
is available from the British Library.

ISBN: 978 1 905267 46 0

Cover design: Mark Blackadder.
Cover image: Montage of the Lewis chessmen
 in National Museums Scotland.
Publication format:
 NMS Enterprises Limited – Publishing.
Printed and bound in the United Kingdom by
 Bell & Bain Limited, Glasgow.

Published by National Museums Scotland as
one of a number of titles based on museum
scholarship and partnership.

For a full listing of NMS Enterprises Limited –
Publishing titles and related merchandise:

www.nms.ac.uk/books

Contents

The Lewis Chessmen: Unmasked

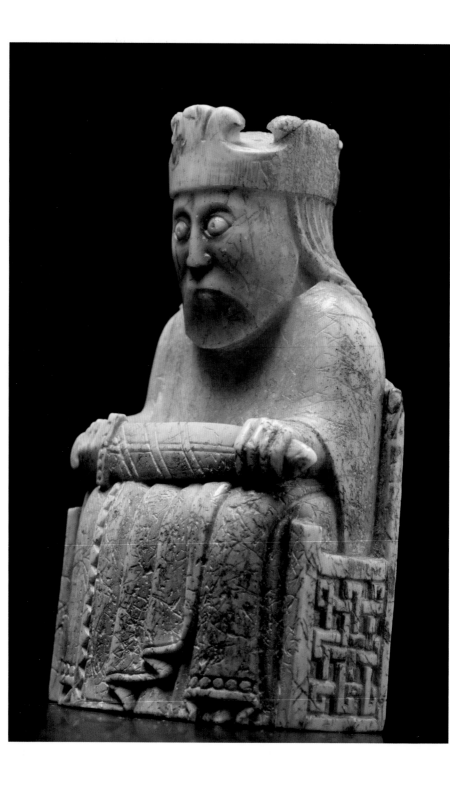

Acknowledgements

THIS book was written to accompany a travelling exhibition in 2010-11 about new research on the Lewis chessmen. It could not have been done without the support and input of many colleagues in National Museums Scotland, and also the help and generosity of colleagues in the British Museum, particularly James Robinson. We are also most grateful to Sally Foster, editor of *Medieval Archaeology*, for allowing work originally published in that journal to reappear here.

David H. Caldwell
Mark A. Hall
Caroline M. Wilkinson

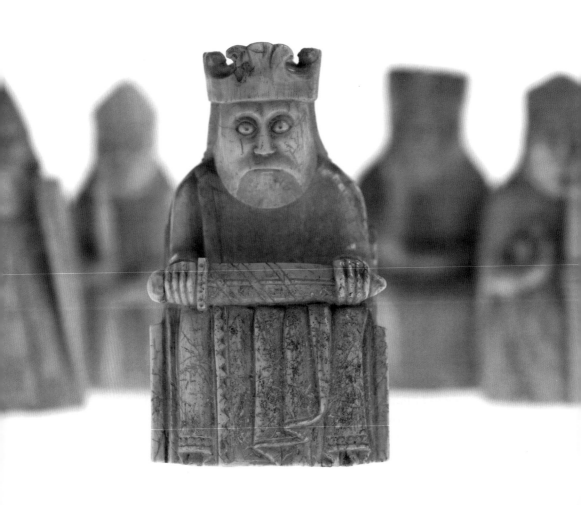

Foreword

Jane Carmichael
Director of Collections
National Museums Scotland

THE Lewis chessmen have long been associated with mystery and romance: mystery about their origins and burial in the Western Isles some eight hundred years ago and the romantic story of their chance discovery in the nineteenth century. The remarkably expressive detailing of the figures gives them a unique immediacy and attractiveness and has made them famous.

Many scholars have been drawn to investigate them. Contemporary scholars have the advantage of drawing on advanced scientific techniques. This book summarises the story of the chessmen and the most recent research in which Dr David Caldwell, of National Museums Scotland, and his team have used forensic analysis combined with historical expertise to review the evidence.

National Museums Scotland and the British Museum are pleased to be partners in creating the exhibition, *The Lewis Chessmen: Unmasked*, with funding from the Scottish Government. This exhibition brings the chessmen together to tell their story and will be shown first at the National Museum of Scotland in Edinburgh. We are delighted to be able to work with our partners across Scotland to take the exhibition to Aberdeen, Lerwick and Stornoway.

We hope that the exhibition and this book, as well as associated events and information on the National Museums Scotland and British Museum websites, will be enjoyed as widely as possible.

May 2010

National Museum of Scotland	21 May to 19 September 2010
Aberdeen Art Gallery	7 October to 8 January 2011
Shetland Museum and Archives	29 January to 27 March 2011
Museum nan Eilean, Stornoway	15 April to 12 September 2011

Introduction

ON 11 April 1831 Roderick Ririe from Stornoway in Lewis had a hoard of 93 pieces of ivory, most of which were readily recognised as chessmen, exhibited in Edinburgh at a meeting of the Society of Antiquaries of Scotland. The Antiquaries were interested in acquiring at least some of them for their museum, but after a delay 82 of the pieces were purchased later that year by the British Museum. The other eleven eventually ended up in the Society of Antiquaries' museum in Edinburgh, now subsumed in National Museums Scotland.

The Lewis chessmen, as they have long been known, are arguably the most well-known treasure ever to have been found in Scotland and certainly one of the most valuable. It is difficult to translate that worth into money, and practically impossible to measure their cultural significance and the enjoyment they have given countless museum visitors over the years. We can be sure that their appeal continues to be very considerable. Since their acquisition by the two museums, they have been almost continuously on display in London and Edinburgh and some have been sent to prestigious exhibitions elsewhere in Britain and also overseas, including Sydney in Australia and to several locations in North America. Both museums have also lent pieces

on a number of occasions for display in Museum nan Eilean in Stornoway.

The Lewis chessmen have acquired an iconic status as the epitome of chessmen. There is worldwide recognition that that is what they are, and art historians have always regarded them as outstanding examples of Romanesque Art – a style of art that was widespread throughout Europe in the twelfth century. They are often featured in books on art or Scandinavian culture, but after more than 170 years there is still some mystery surrounding how and when they got to Lewis and a lot to be said about their true significance. This book reviews the Lewis chessmen story and shows how they can tell us a lot more about our history and heritage.

The Lewis Chessmen
Unmasked

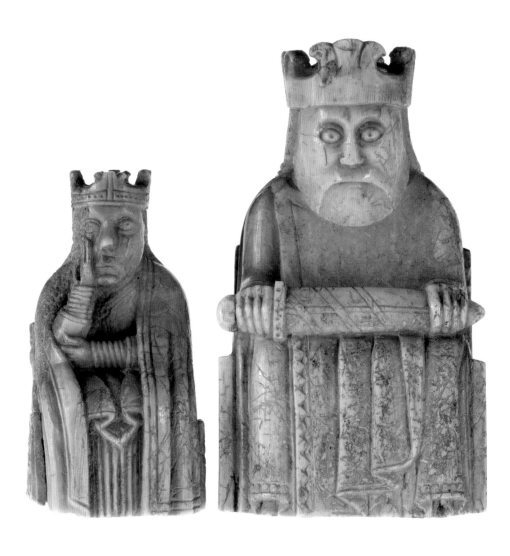

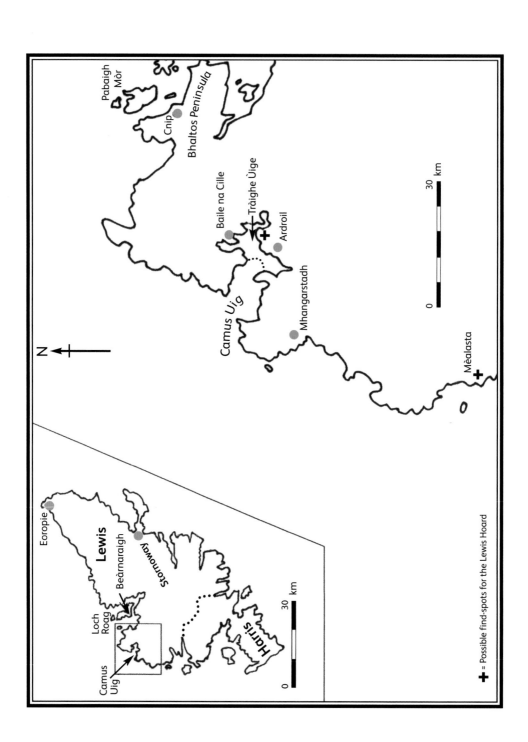

Pabaigh Mòr

Cnip

Bhaltos Peninsula

Baile na Cille

Tràighe Ùige

Ardroil

Camus Uig

Mhangarstadh

Mèalasta

N

30 km

0

Eoropie

Lewis

Loch Roag

Beàrnaraigh

Stornoway

Harris

Camus Uig

30 km

0

+ = Possible find-spots for the Lewis Hoard

The Hoard's Discovery

HOW and where the hoard was discovered has always been a subject of interest. It has long been believed that Malcolm MacLeod, a resident of the settlement of Peighinn Dhomhnuill (Penny Donald – since cleared) in the Parish of Uig on the west coast of the island, discovered it in a sandbank in the Mains of Uig. This locates the find-spot in an area of sand dunes at Ardroil on the south side of Tràighe Ùige (Uig Strand) [Fig. 1]. Lewis is a part of the world where there is a strong tradition of storytelling, and it is not surprising that the hoard's discovery was no sooner public knowledge than an explanation for its loss was found.

According to the most well-known story, sometime in the seventeenth-century a servant of the MacKenzie tacksman (tenant) of Baile na Cille, known as 'An Gille Ruadh' (the Red Gillie), spied a young sailor fleeing his ship with a bundle, which turned out to contain the Lewis chessmen. The gillie at first befriended the youth, but then murdered him for the sake of his treasure and buried it for recovery at a later date. That he never managed to do, and his crime was only uncovered when he himself confessed it some time later on the scaffold at Stornoway as he was about to be executed for other misdemeanours.

Needless to say, there is no record of this tale being told prior

Opposite:

1. MAP OF LEWIS

This map shows possible find-spots for the Lewis hoard.

to 1831. As a story it no doubt satisfied and amused countless *Lèodhasaich* (natives of Lewis) as it was recounted over the years, but it had the unfortunate effect of reinforcing a belief that somehow the hoard did not belong in Lewis but only got there by accident. The story's origin can be traced to Donald Morrison, known as *An Sgoilear Bàn*, a noted local storyteller. Morrison died in 1834, but left a manuscript of his stories for others to use. It is now preserved in Stornoway Public Library and was fully published in 1975.

Very little is known about Malcolm MacLeod, the hoard's finder. Indeed, the first time his name is actually recorded is in 1863, and none of the nineteenth-century experts who wrote on the hoard seem to have had the opportunity to meet or to discuss his discovery with him. Morrison the storyteller appears to be the source for the hoard being found in the sands at Uig Strand, but, remarkably, the earliest accounts of the hoard give a completely different find-spot.

On 29 June 1831 *The Scotsman* newspaper reported that the chessmen had recently been acquired by an Edinburgh dealer, Mr J. A. Forrest (listed in contemporary records as a watchmaker, jeweller and medallist). They had been found some months previously by a 'peasant of Uig' near the ruins of a nunnery in Uig, known as Taigh nan Cailleachan Dubha (the house of the black women). Ririe, the man who had brought the pieces to Edinburgh, had apparently sold them to Forrest, but not before he had allowed an Edinburgh collector, Charles Kirkpatrick Sharpe, to purchase ten of them. It is these ten, plus an eleventh later acquired by Sharpe from Lewis, that are now in National Museums Scotland. Forrest sold the rest to the British Museum.

Charles Kirkpatrick Sharpe [Fig. 2] is our source for yet more detailed information on the chessmen's find-spot. According to him, they were found in a vaulted room about six feet (1.83 metres) long. They were partially buried in sand and the floor was covered with ash. The chamber was located near 'the house of the black women', where tradition affirmed a nunnery once

stood. Sharpe also described the chamber as similar to a small subterranean stone building, like an oven. It was at some depth below the surface and some distance from the shore, and was only exposed after a sudden and very considerable inroad by the sea. 'The peasant' discoverer had to break into this structure to find the hoard.

Sharpe is a particularly important witness since he dealt directly with Roderick Ririe. Indeed, Ririe may have been 'the gentleman from Stornoway' that, according to a late nineteenth-century source, dug out pieces which were not recovered by Malcolm MacLeod himself. So where was this underground chamber? The answer is very easy, since its location can be identified by its proximity to the alleged nunnery, at Mèalasta on the west coast of Lewis, still within the Parish of Uig but about six miles south of Uig Strand [Fig. 3]. There are no traces now of any structure that could be identified as a nunnery, and

2. CHARLES KIRKPATRICK SHARPE

(Source: The Walter Scott Digital Archive, Edinburgh University Library)

indeed this appears to be a red herring. There are no documentary sources suggesting that there was a nunnery here in medieval times, only the opinion of the minister of Uig, writing in the 1790s, that its remains could be identified.

The underground chamber is much more plausible. From the descriptions supplied by Sharpe it might be identified as a souterrain, an underground structure dating to the Iron Age or Early Medieval Period, perhaps used for storage. These are fairly widespread throughout Scotland, and from other sources one is known to have existed at Mèalasta. It was described in 1870 as consisting of a gallery terminating in a bee-hive chamber, but by that time its stones had been removed for building purposes. Intriguingly, a circular stone chamber, about two metres in diameter and accessed by a passageway, lies under the medieval house at Jarlshof in Shetland, a complex site with occupation extending back to the Bronze Age. The excavators could not be sure of its age, but the wind-blown sand that accumulated within it contained a slate inscribed with a Viking age interlace pattern.[*]

Whereas the sand dunes at Uig Strand now appear a desolate and secluded spot, Mèalasta has evidently been an important local settlement with relatively good soil and access from the sea. There is the site of a medieval church with a burial ground and, adjacent to the spot marked on Ordnance Survey maps as the site of the nunnery, the sea is weathering out midden deposits from which a bronze finger ring was recovered a number of years ago and awarded as Treasure Trove to Museum nan Eilean in Stornoway. The ring is engraved with crosses and dates to the twelfth or thirteenth century.

All this suggests that Mèalasta is to be preferred to the sands of Uig Strand as the hoard's find-spot. However, there is one further source that backs this up. When the Ordnance Survey

[*] J. R. C. Hamilton: *Excavations at Jarlshof, Shetland* (Edinburgh: HMSO, 1956), p. 76 and pl. XIIIb.

mapped the Parish of Uig in 1852-53 for the first time, they
noted in their 'Name Book' that chessmen, which were sold to 'a
society of antiquaries in Edinburgh', were found in the ruins of a
nunnery about seventy years previously. Nothing then remained
of it but the site. Not only does this appear to verify the infor-
mation supplied through Charles Kirkpatrick Sharpe, it also
raises the interesting possibility that some or all of the chessmen
could originally have been discovered in the 1780s. It is not
beyond the bounds of likelihood that pieces from the hoard
could have remained in a local house or barn for fifty years, their
value and interest unappreciated until a travelling merchant –
Roderick Ririe even? – saw them and spotted a chance to make
some money. Might it even be the case that the story of the nun-
nery was created on the back of the discovery of the chessmen?
That, of course, is speculation, but Mèalasta may yet have a lot
to tell us.

3. MÈALASTA
(Source: © Stuart
Campbell)

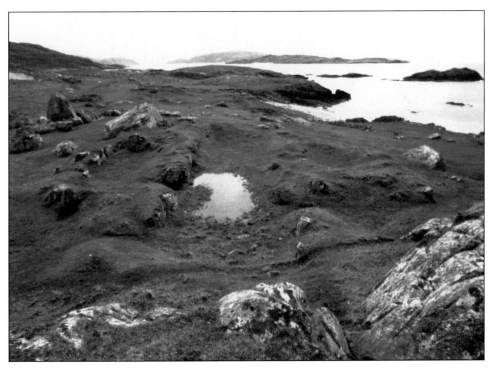

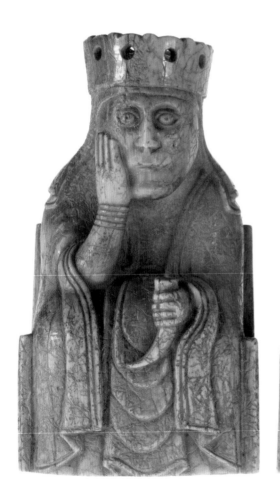
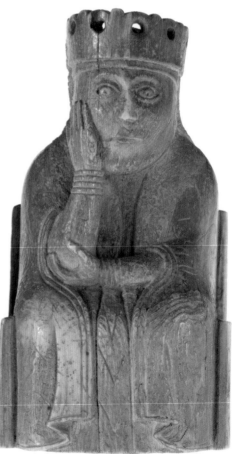

The Contents
of the Hoard

RODERICK Ririe brought 93 ivory pieces to Edinburgh in 1831 [Figs 4.1-63]. These included a buckle, decorated with foliage designs, that may have fastened a leather or textile bag containing the rest of the hoard. While ivory can survive well in the ground over hundreds of years, it takes very special circumstances, normally permanent water-logging, for cloth or leather to remain intact for any length of time. There are also 14 plain disks, about 55 to 60 millimetres in diameter, which are clearly men for playing a board game. The remaining 78 pieces can readily be identified as chessmen, including kings, queens, bishops, knights, warders (equivalent to rooks today) and pawns. All but the pawns are figurative, that is modelled in considerable detail as humans with appropriate clothing and equipment. These face-pieces vary in height from 70 to 103 millimetres, and the pawns from 40 to 59 millimetres. While the detailing of the face-pieces is realistic, they are not in true human proportions but have comparatively large heads and clothing to the ground to create broad steady bases for ease of play.

The most economical explanation for this group of 78 is that they represent the remains of four chess sets, each, then as now, containing two sides with a king, a queen, two bishops, two knights, two warders/rooks and eight pawns. In that case

Opposite:

4.1-4.63 THE
LEWIS HOARD OF
GAMING PIECES

(Source: *Medieval
Archaeology* 53 [2009],
155-203)

the missing pieces are a knight, four warders and 45 pawns. Perhaps they were hidden away with the rest, but were too fragmentary to be recovered. Those that were recovered vary considerably from near perfect to ones which are cracked and have bits missing. Despite early reports that some bore traces of staining, presumably so that a red side could be distinguished from a white side, scientific analyses in recent times have so far failed to identify any substance that could have been used to colour them. It would be possible, however, to group them into four sets on the basis of size alone. Altogether, with the missing pieces and some more tables-men, the hoard could have weighed as much as 1.5 kilograms and have occupied a box or bag about 200 by 350 by 250 millimetres.

NOTE ON FIGS 4.1-4.63

The captions to the Figures on pages 23-29 take the following form:

- The piece type (e.g. King, Queen, Bishop, etc.)

- The piece number (pieces 19-29 in National Museums Scotland)

- The height (in millimetres)

- The group (see the chapter on pages 55-65, 'Analysing the Chessmen') – e.g. A-E, X – and the set number (1-4)

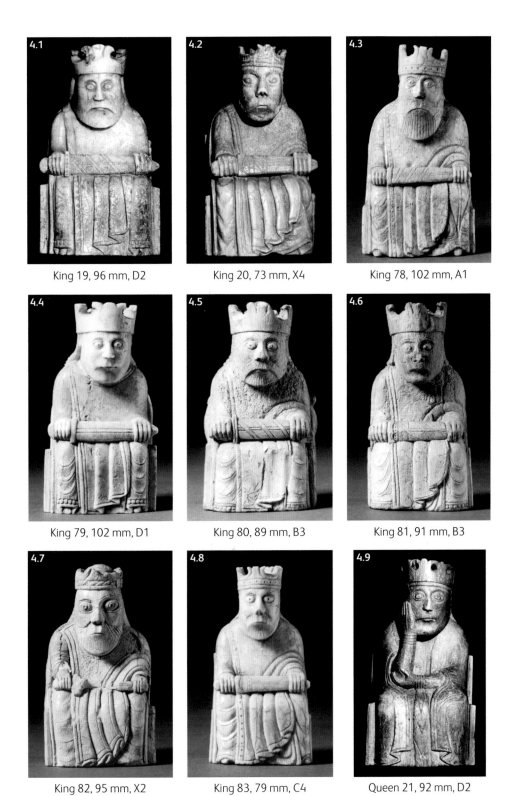

4.1 King 19, 96 mm, D2

4.2 King 20, 73 mm, X4

4.3 King 78, 102 mm, A1

4.4 King 79, 102 mm, D1

4.5 King 80, 89 mm, B3

4.6 King 81, 91 mm, B3

4.7 King 82, 95 mm, X2

4.8 King 83, 79 mm, C4

4.9 Queen 21, 92 mm, D2

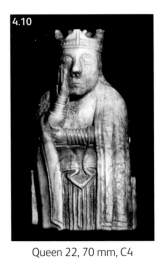

Queen 22, 70 mm, C4

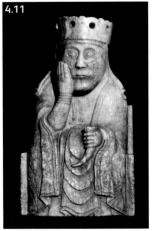

Queen 23, 93 mm, D2

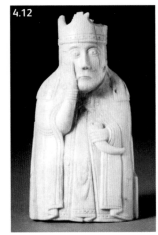

Queen 84, 96 mm, C1

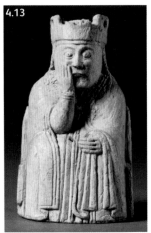

Queen 85, 80 mm, B3

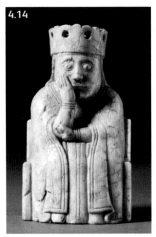

Queen 86, 80 mm, B3

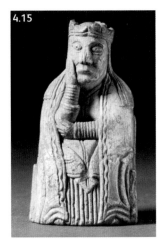

Queen 87, 76 mm, X4

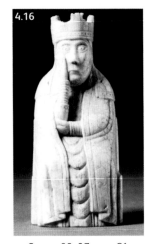

Queen 88, 97 mm, C1

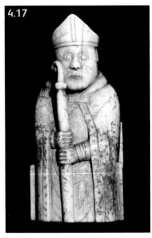

Bishop 24, 92 mm, E2

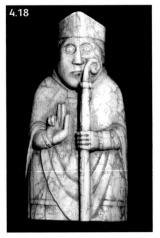

Bishop 25, 93 mm, D2

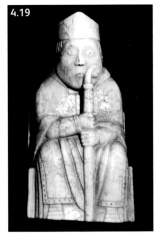

Bishop 26, 73 mm, B4

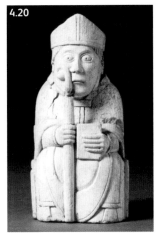

Bishop 89, 97 mm, D1

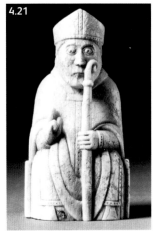

Bishop 90, 97 mm, D1

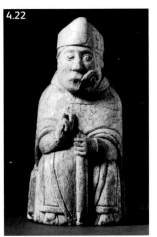

Bishop 91, 87 mm, B3

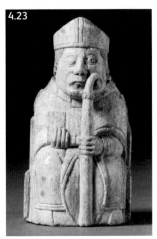

Bishop 92, 82 mm, B4

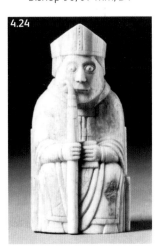

Bishop 93, 82 mm, D4

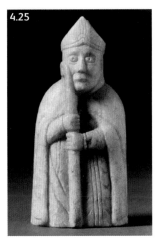

Bishop 94, 89 mm, C3

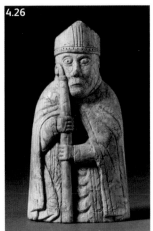

Bishop 95, 95 mm, C2

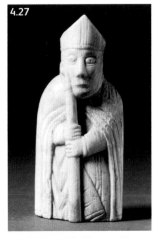

Bishop 96, 95 mm, C1

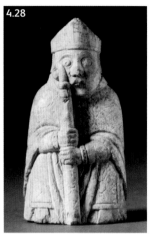

Bishop 97, 76 mm, B4

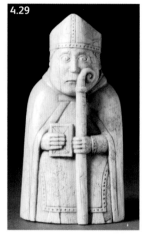

Bishop 98, 95 mm, D2

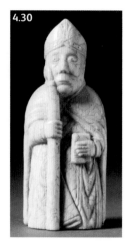

Bishop 99, 83 mm, C3

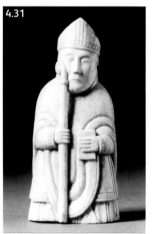

Bishop 100, 102 mm, C1

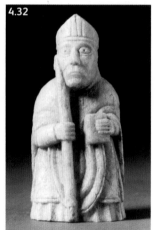

Bishop 101, 83 mm, C3

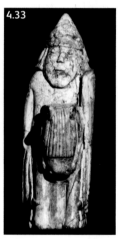

Knight 27, 89 mm, X2

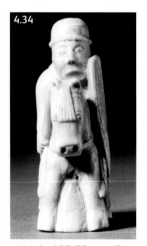

Knight 102, 73 mm, C4

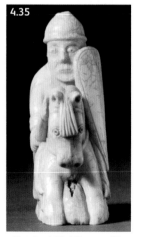

Knight 103, 73 mm, C4

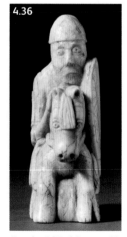

Knight 104, 88 mm, C3

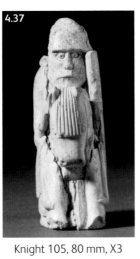

Knight 105, 80 mm, X3

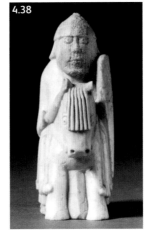

Knight 106, 80 mm, X3

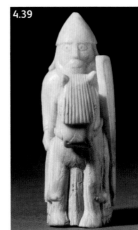

Knight 107, 84 mm, A3

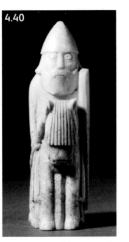

Knight 108, 89 mm, A2

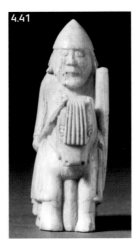

Knight 109, 79 mm, B4

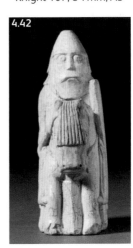

Knight 110, 91 mm, A2

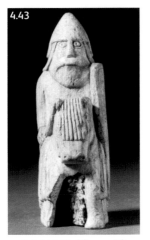

Knight 111, 90 mm, A2

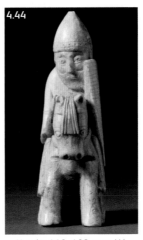

Knight 112, 103 mm, X1

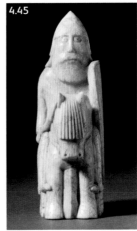

Knight 113, 100 mm, A1

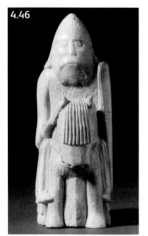

Knight 114, 101 mm, A1

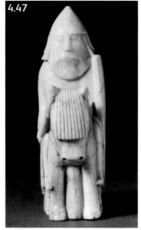

Knight 115, 100 mm, A1

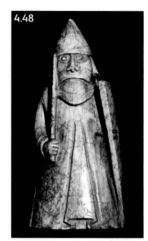

Warder 28, 92 mm, E2

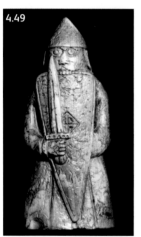

Warder 29, 82 mm, E3

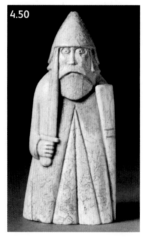

Warder 116, 100 mm, A1

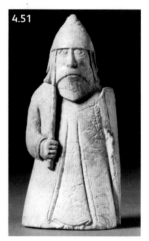

Warder 117, 98 mm, A1

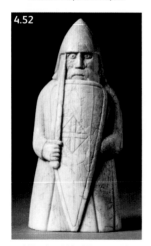

Warder 118, 93 mm, A2

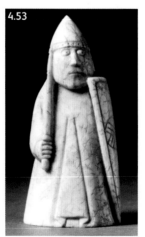

Warder 119, 90 mm, D2

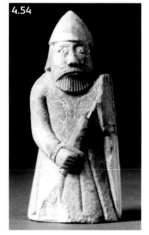

Warder 120, 89 mm, B3

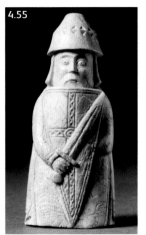

Warder 121, 79 mm, X4

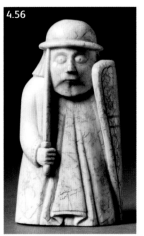

Warder 122, 71 mm, D4

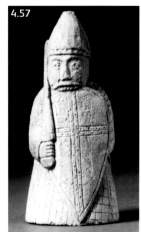

Warder 123, 92 mm, X2

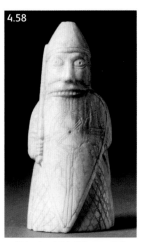

Warder 124, 85 mm, C3

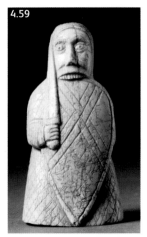

Warder 125, 82 mm, C3

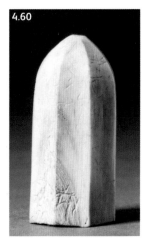

Pawn 133

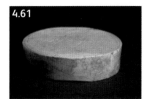

One of the tables-men

The Buckle

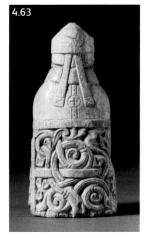

Back of bishop 91

KINGS

The kings [Fig. 5] are all seated on thrones and hold a sword across the knees, right hand on the grip and left hand grasping the scabbard or blade. All but one has long hair worn in braids and most or all appear to be bearded. They wear open crowns with four trefoil ornaments and are robed in long mantles fastened at the right shoulder, with a tunic or dalmatic (a vestment with sleeves and slit sides) underneath.

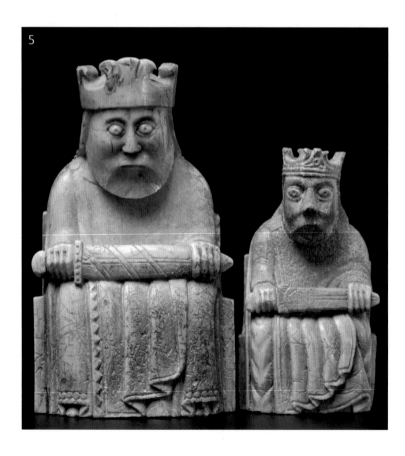

5

30

The queens [Fig. 6] are also enthroned and crowned. Four crowns are similar to those worn by the kings, but on the other four the trefoils have merged to form a continuous, pierced band. Their hair, worn long in braids, is covered by a veil. Two queens hold drinking horns in their left hands, the rest support their right elbows with their left hands. All are clad in long mantles or cloaks which cover their shoulders but leave a gap down the front. Three are fastened at the neck. Under them they have a gown with close sleeves. In two cases these gowns are cut off at the knees and display an undergarment extending to the feet.

National Museums Scotland queens (NMS 22, 23 and 21, left to right)

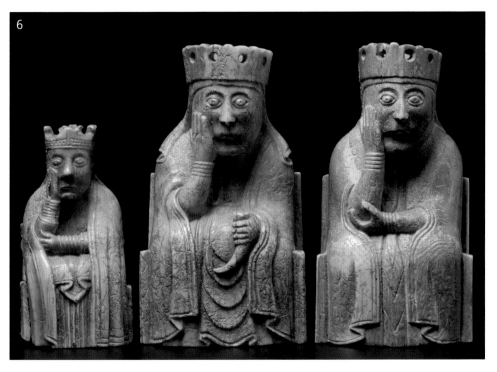

6

BISHOPS

National Museums
Scotland bishops
(NMS 26, 25 and 24,
left to right).

The bishops [Fig. 7] show the greatest variety in terms of design. Some are seated on thrones, and all wear mitres, have cropped shoulder length hair and are clean shaven. Five wear a cope (cloak) as their outer garment, the rest have chasubles (sleeveless vestments). These are worn over a dalmatic, followed by a stole (a scarf-like garment of silk, etc.), and, next to the skin, an alb (a white vestment reaching to the feet). All these items of clothing differ little from the vestments still worn by priests today when officiating at masses and sacraments. Each bishop also holds a crosier, grasped with one or two hands, the crook either facing right or left. Some hold a book or have their right hand raised in blessing.

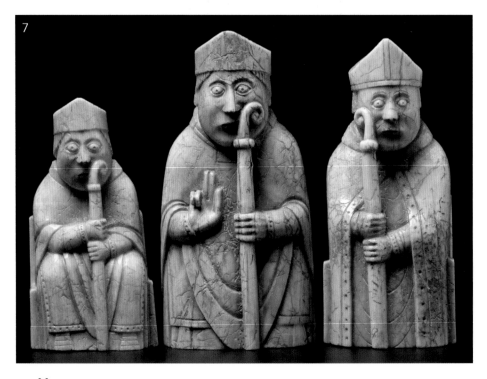

7

The knights [Figs 8.a, b] and warders [Fig. 9, page 34] seem mostly to be bearded and wear protective coats, divided at front and back for ease in moving and especially for sitting astride a horse. They probably represent originals of hide or leather. Three warders are represented as having hauberks (mail coats), two of them with coifs (hoods), but otherwise head-gear consists mostly of helmets or else kettle-hats. The helmets are conical, many with protective flaps for the ears and back of the neck. Some of the kettle-hats are like twentieth-century bowler hats, but two have a distinctive carinated (keel-like, with a horizontal ridge) outline. They are all provided with large kite-shaped shields, many of which have geometric designs, especially of crosses. Three of the warders are carved biting the top of their shields. The knights all have spears and the warders drawn swords. The knights' horses, in appearance and relative proportions, look – presumably misleadingly – like present-day Shetland ponies.

KNIGHTS AND WARDERS

National Museums Scotland knight from left and right sides (NMS 27).

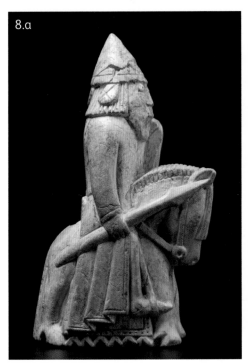

8.a

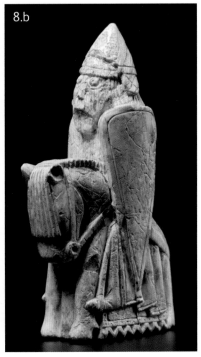

8.b

WARDERS

National Museums
Scotland warders
(NMS 29, berserker,
left and NMS 28
warder, right).

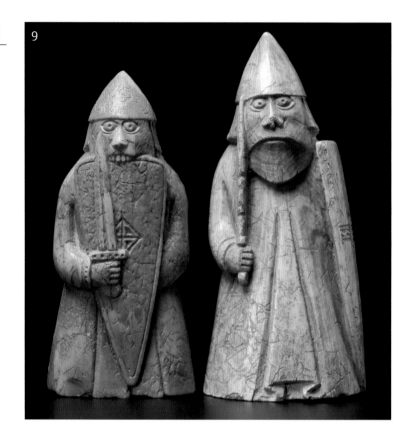

9

PAWNS

The pawns [see Fig 4.60] are either slab-like or bullet-shaped
and faceted. Two of them have engraved decoration.

Drawings of the
pawns in Frederic
Madden's paper in
*Archaeologia: or
Miscellaneous Tracts
relating to Antiquity*.

(*Source:* Society of
Antiquaries of London,
vol. xxiv, 1832)

10

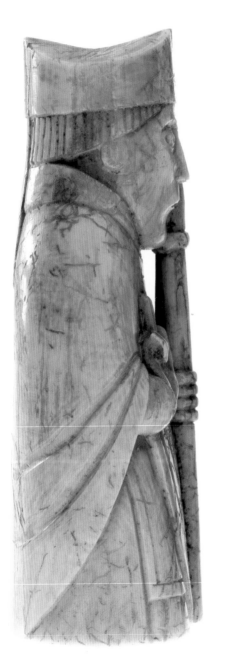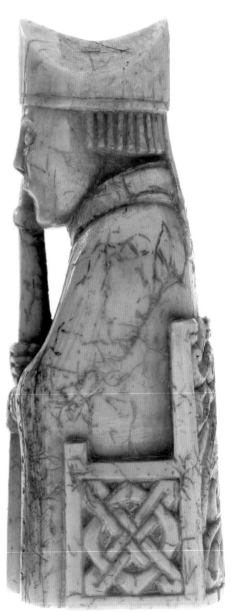

Why Twelfth-century Scandinavian?

FROM the outset there have been no serious doubts about the Scandinavian origin of the Lewis chessmen. They are mostly made of walrus ivory and that tends to favour a northern European origin rather than one further south, although, undoubtedly, uncarved walrus tusks could readily have been traded for use by craftsmen in centres far away from the seas around Iceland and Greenland where the animals thrived. Useful comparisons have been made between the carving on the thrones occupied by kings, queens and bishops and other ivory carvings with a Scandinavian provenance, with the wood carvings of Norwegian stave churches, and with architectural sculpture in Trondheim Cathedral in Norway – all material datable to the twelfth century. Two other ivory chessmen are known from Scandinavia which are so similar to the Lewis chessmen that they could have come from the same workshop at the same time. One is a knight from Lund in Sweden (in Kulturen, Lund), and the other (now lost) is a queen from Trondheim. Both are fragmentary.

None of this provides proof of a Scandinavian origin, and it has to be said that much of the art and culture of twelfth-century Europe, and clothing and equipment, was truly international, extending from Norway and even Greenland and Iceland, to

Sicily and the Crusader states in the Holy Land. There is one feature of the Lewis chessmen, however, which is difficult to believe could have originated anywhere else but the Scandinavian world, and that is the warders shown biting their shields [Fig. 4.49 (see Fig. 9 and image opposite) and Figs 4.57-59]. This is believed to indicate that these men were *berserkers*, warriors who fought in an uncontrollable fury, possibly trance-induced. Berserkers are said to have fought naked, but it is possible that the carvers of the Lewis chessmen, in showing their warders gnashing their teeth, were deliberately poking fun at some of their contemporaries. The idea is solely Scandinavian and it is doubtful if warriors elsewhere would have chosen to be represented in this way.

In terms of dating, a key consideration is the form of the mitres worn by the bishops. These have peaks or horns, front and back, as mitres worn ever since. It is known that prior to about 1150, bishops wore their mitres with the peaks to the sides. A date about the third quarter of the twelfth century is now generally suggested for the chessmen, and no scholars have dated them any later than the twelfth century. One reason for this is the lack of obvious heraldry on the shields of the knights and warriors. Heraldic designs, as badges of individuals and families, were appearing before the end of the twelfth century.

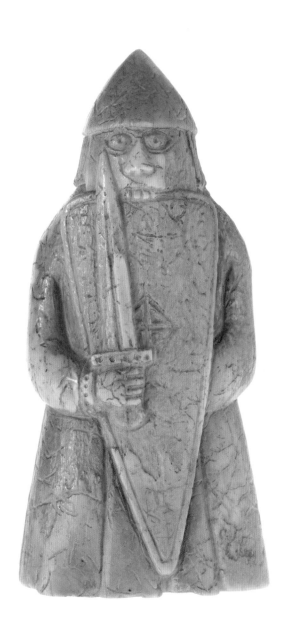

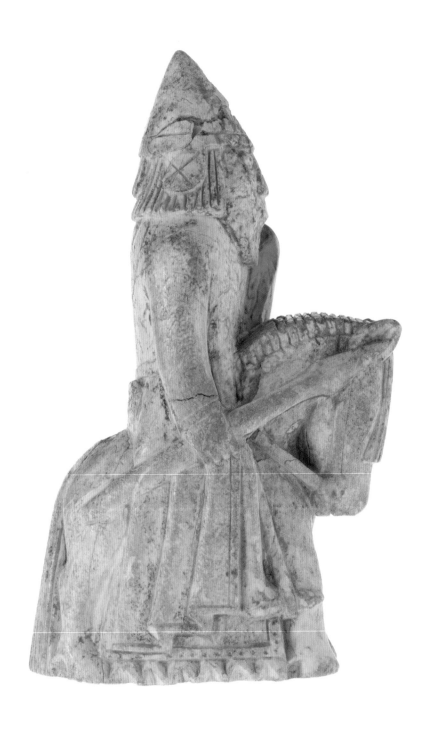

How Lewis?

FOR many, Lewis is a remote part of the British Isles, off the beaten track and with a landscape of moors and bogs that does not support a large population. Uig Strand, a desolate, wind-swept area of sand dunes, is just the place that a treasure would be buried, especially if it had come by sea. It is perhaps not surprising that those art historians who have studied the chessmen have assumed that their Lewis provenance was largely accidental. How else could the presence of such fine works of art be explained in such a place? The story of the run-away sailor murdered by the Red Gillie was difficult to swallow. It was much more likely that the hoard belonged to a merchant who was sailing from Scandinavia to markets further south in Ireland or England. Perhaps he was shipwrecked and had to bury his stock as best he could until he could come back and recover it. He may also have hoped to hide the fact that he had landed goods so that he could escape paying hefty tolls to local officials of the King of the Isles. This is what happened to another merchant ship, blown off-course in 1202 and forced to land on Sanday, next to Canna in the Inner Hebrides, as reported by a passenger, Gudmund, bishop-elect of Holar. Whatever the particular circumstances, the person who buried the hoard must have intended rescuing it again and taking it off to somewhere where

fine chessmen could be appreciated. Some other disaster must have prevented this happening.

While this reconstruction of events is plausible, it is by no means the only one. It also pays scant regard to Lewis and what sort of place it was at the time the chessmen were made. In many ways that is the key to gaining a fuller understanding of the hoard.

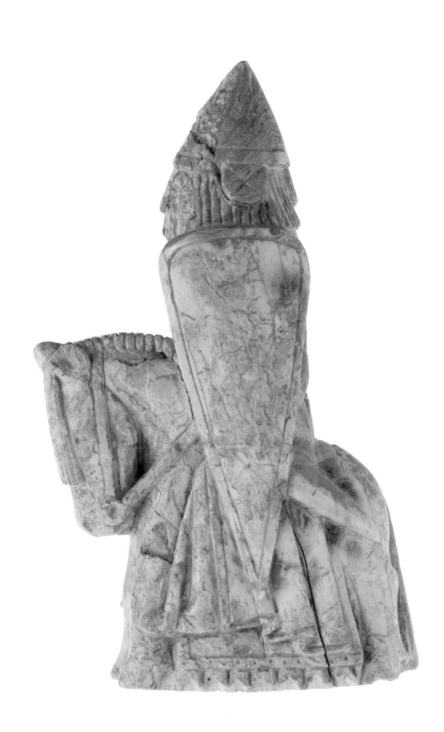

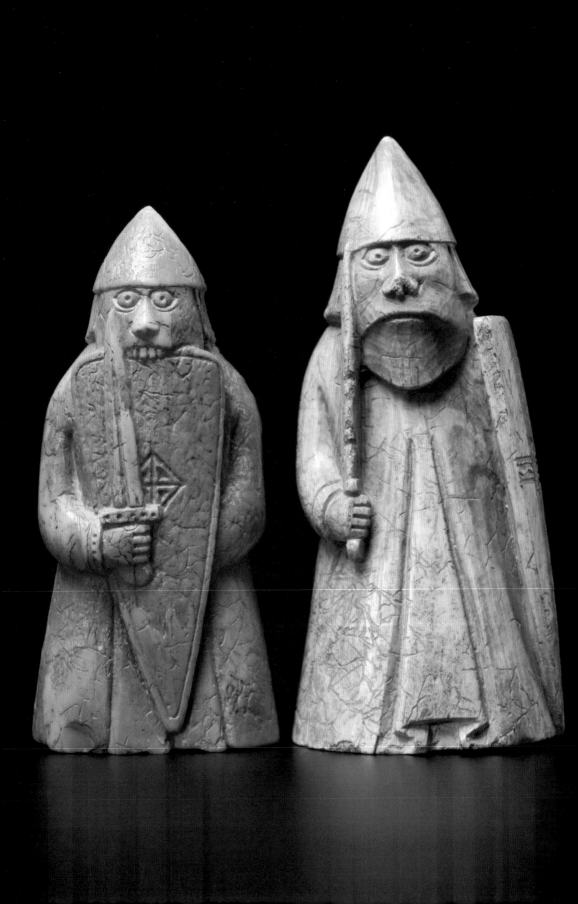

Lewis and the
Kingdom of the Isles

FROM the end of the eighth century many parts of the British Isles were subjected to raids by the Vikings, pirates from Scandinavia. In the case of the Western Isles of Scotland these men came from Norway, and by the mid-ninth century many of them were settling down. Local Gaelic-speaking populations were removed, slaughtered or at least suppressed, and the islands became part of a wider Scandinavian world with strong links being maintained with the Norwegian homeland.

Archaeological evidence suggests that the main centre of occupation in Lewis by early Scandinavian settlers was in the parish of Uig. At Cnip Headland there is a pagan Viking cemetery which is the largest known concentration of such burials in the Hebrides. Included is the burial of a wealthy female, with another such interment nearby at Bhaltos School. There is reason to think that the parish of Uig continued to be a relatively important area through the medieval period. The Macaulays, who claimed descent from King Olaf of the Isles (ruled 1226-37), are said, at least by about 1400, to have had their main residence at Chradhlastadh (Crowlista), looking south across Camas Uig to Uig Strand. The main Lewis-based family in the medieval period – the MacLeods – are said to have had a residence on the island of Beàrnaraigh (Great Bernera).

Much of what we know about events in the Isles in medieval times is derived from *The Chronicles of the Kings of Man and the Isles*, seemingly written on the Isle of Man. They tell us that in 1079 Godred Crovan established himself as King of the Isles, and the kings descended from him continued to rule over the Isles until the 1260s. The kingdom included all the Hebrides and the Isle of Man where the kings were based. As time went on, it is clear that Gaelic culture and language re-emerged, so that by the twelfth century the kingdom was a hybrid Norse-Gaelic state. Its kings recognised the overlordship of the Kings of Norway: Kings of the Isles and other local leaders were required to go to the royal court in Norway and Norwegian kings intervened directly in the affairs of the Isles. In 1152, or the following year, the Archbishopric of Nidaros (Trondheim) was created and the new archbishops were given power over the bishops of the Isles, who had authority over all the churches in the kingdom of the Isles. The Hebrides only reverted to Scottish rule by the treaty of Perth in 1266, but the archbishops of Nidaros continued to exercise their power there for some time afterwards.

The authority of the kings descended from Godred Crovan was by no means unchallenged, especially from the mid-twelfth century by a local prince, Somerled, and his descendants, including the MacRuaris, the MacDougalls and the MacDonalds. Somerled defeated King Godred Olafsson in a sea-battle in 1156 and soon afterwards claimed kingship over the Isles. Although Godred reclaimed his kingdom after the death of Somerled in 1164, he and his successors were to find the MacSorleys (Somerled's descendants) troublesome subjects or rivals. In 1249 it appears that King Hakon of Norway was obliged to recognise Ewen (MacDougall) as king over the northern part of the Hebrides. This was an acknowledgement that there was no longer a unitary kingdom of the Isles and that the kings based in the Isle of Man were unable to control other islands. Ewen's territory is not defined and may only have included Skye and Lewis, although he would already have held the Mull group of

islands by inheritance. As Ewen was a subject of the King of Scots for mainland territories, he immediately came under pressure from King Alexander II to give up his Norwegian allegiance. He was forced to flee to Lewis, and his position as King of the Isles was assumed by his main MacSorley rival, Dugald (MacRuari), who remained the main power in the Hebrides, from a Norwegian perspective, until the 1260s.

There is little information on Lewis itself in this period. The Viking activities of the Orkney nobleman Sveinn Asleifarson, in the middle of the twelfth century, suggest that Lewis, where he had a friend called Ljotolf, was a good base for himself and his brother Gunni when the latter was forced into exile by Earl Harald of Orkney. Perhaps at that time Lewis was neither under the firm hand of Godred Olafsson nor Sveinn's friend Somerled.

Godred Olafsson appointed his son Olaf as his successor, but since he was only a boy at the time of Godred's death in 1187 the Manx people chose his elder half-brother Rognvald as king. Rognvald gave Lewis to Olaf. Olaf found that the island was unable to sustain himself and his army and he therefore came to his brother, who was then in the Isles, and asked him for some better portion of lands. Rognvald, after promising to take counsel with his own men, had Olaf bound in chains and handed him over to be imprisoned by William King of Scotland. Immediately prior to his death seven years later (in 1214), William ordered the release of all his prisoners, including Olaf. Olaf returned to his brother Rognvald in Man and shortly afterwards went with a retinue of nobles to visit the shrine of St James (at Compostella). On his return, Rognvald had Olaf marry Lauon, his own wife's sister. He granted him Lewis and the newly married pair went off to settle there. There are no clues as to why the King of Scots should have wished to imprison Olaf or, perhaps a related matter, why Olaf sought the intercession of St James for his sins.

Perhaps Lewis was in the sway of the MacSorleys and Olaf was intended to bring it back to the allegiance of his brother. Hence the need for an army, and, it should be noted, Rognvald

was also in the Isles at that time, very probably also campaigning to regain territory. But if Lewis was peaceful on Olaf's return to it, his own life there was to be drastically upset a few days later on the arrival of his uncle, Bishop Rognvald of the Isles, to undertake a visitation of the island's churches. The bishop refused to join Olaf in the great banquet prepared in his honour, on the grounds that Olaf's marriage to Lauon was illicit in the eyes of the Church. This was because Olaf had previously kept Lauon's cousin as a concubine.

The bishop proceeded to hold a synod at which the wedding was annulled. Since Olaf married a daughter of the powerful Earl of Ross soon afterwards, we may wonder if Olaf really was a passive, unwitting victim of the bishop's censure. Certainly Lauon's sister, the queen, was furious and sought to get her revenge on Olaf. She ordered her husband's son Godred to kill Olaf, who was obliged to flee Lewis in 1223. Nevertheless, Olaf recovered his position, forcing King Rognvald to split his kingdom with him, and succeeding him as king in 1226.

Olaf did not enjoy peaceable control of all his kingdom for very long. In 1230 he divided his kingdom with his nephew Godred Don. Olaf kept Man, while Godred Don got the Isles (unspecified). It is clear that some of the Isles at that time were held by the MacSorleys, possibly including Lewis. Godred Don was killed soon afterwards in Lewis, perhaps attempting to regain it for himself. In 1231 a Norwegian army, returning home from aiding Olaf, also went to Lewis. What it achieved there is not known, except that it forced Tormod son of Torquil to flee, and captured his wife along with a great treasure that belonged to her husband. Tormod was the ancestor of the MacLeods of Lewis.

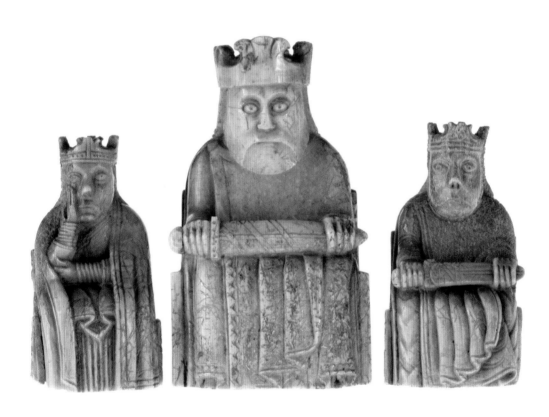

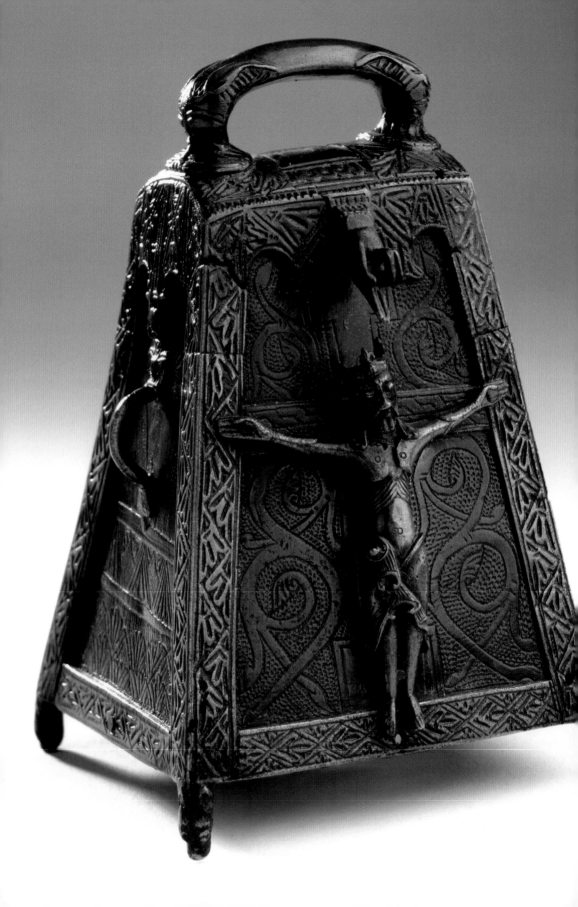

The Lewis Chessmen
in Lewis

S UPPOSING the hoard was not abandoned accidentally by a merchant on his way elsewhere, then the story of the brothers Rognvald and Olaf, and all the events we have just outlined, are of considerable importance in understanding the hoard. Although the documentary sources are meagre, they do demonstrate that Lewis was home to some important individuals – men who might well have owned chessmen as prestigious and valuable as those now in National Museums Scotland and the British Museum. This was obviously the case with Olaf, who would presumably have maintained a princely lifestyle while based on Lewis. Some scholars believe that Rognvald, by giving him that island, was effectively recognising him as his sub-king or viceroy.

Then there is Bishop Rognvald, himself a member of the Manx royal family, and his immediate predecessors and successors as bishop. They should have gone to Trondheim for consecration and for other church business. Rognvald very probably did. Might an archbishop, keen to impress and win the loyalty of his bishop in the Isles, have given such a present?

And what about Tormod? His great treasure was presumably not the Lewis chessmen since it was carried off by the Norwegian army, but it is noteworthy that there were treasures to be had on the island.

Opposite:

13. KILMICHAEL GLASSARY BELL SHRINE

This bronze reliquary (NMS H.KA 5) was made in the 12th century to contain the bell of an early saint.

A MacSorley cannot be dismissed as a possible owner. Some of them were great warriors, holders of extensive lands, and were recognised as kings. One in particular is worth considering here, and that is Angus Mor, a great grandson of Somerled, whose main centre of power was the island of Islay. A praise poem written in his honour in the mid-thirteenth century describes how he inherited his ivory chessmen from his father Donald. It also describes him as King of Lewis – flattery yes, but Angus was clearly a big man in the world of the Isles, Scotland and Ireland. As son of Donald he was the first MacDonald, and also one of the commanders of the invasion fleet which King Hakon used to threaten Scotland in 1263.

Excavations directed by Dr David Caldwell at Finlaggan on the Isle of Islay, probably Angus Mor's main home, produced no chessmen but many tables-men – three of bone and about fifty of stone – probably all of later date than Angus. It is not without interest, however, to note that Angus' praise poem also records how his father Donald left him his dog leashes and hounds. The bronze mounts from two dog collars were found in midden material dating to the 13th century. They include two fine quality swivel attachments with dragonesque heads [Fig. 11].

Great men like these did not lead a sedentary life, but moved from house to house, went campaigning and visiting their lands, tenants, churches and clergy. It is possible that one such as these would have hidden or secured their chessmen in an underground chamber, no doubt adjacent to a favoured residence, until their return from a voyage.

The Lewis chessmen are not the only items from parts of modern-day Scotland that demonstrate the ongoing Scandinavian heritage in the twelfth and thirteenth centuries. An enamelled copper plaque with an image of Christ has been recovered from a grave in Teampull Bhuirgh (Castle Chapel) at Borve, Benbecula, in the Outer Hebrides [Fig. 12]. It would originally have decorated the reverse of a large crucifix, but seems to have been reused, probably as a morse or clasp to fasten

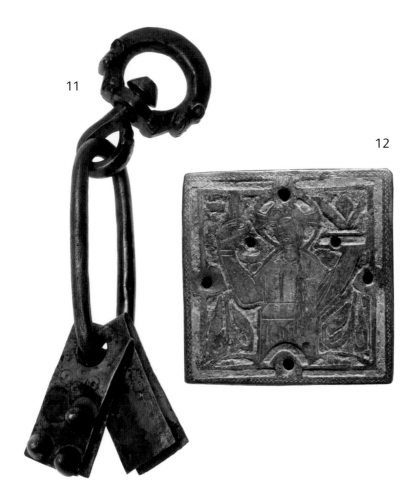

11

12

the cope of a cleric. It is believed to be Scandinavian work of the mid-thirteenth century.

A superb, copper alloy bell-shrine from Kilmichael Glassary in mainland Argyll demonstrates the fusion between Scandinavian and Gaelic culture in the twelfth century [Fig. 13]. In many of its details, and in conception as a receptacle for a relic of a local saint, it is a 'Celtic' work. The figure of Christ in the Crucifixion on the front of the shrine, and the background scrollwork, are Scandinavian in style. It could really only have been produced in Argyll or the Western Isles.

11. A DOG COLLAR MOUNT

From Finlaggan.

12. ENAMELLED COPPER PLAQUE

Enamelled plaque (NMS H.KE 18) with an image of Christ, from Teampull Bhuirgh, Borve. Scandinavian, mid-13th century.

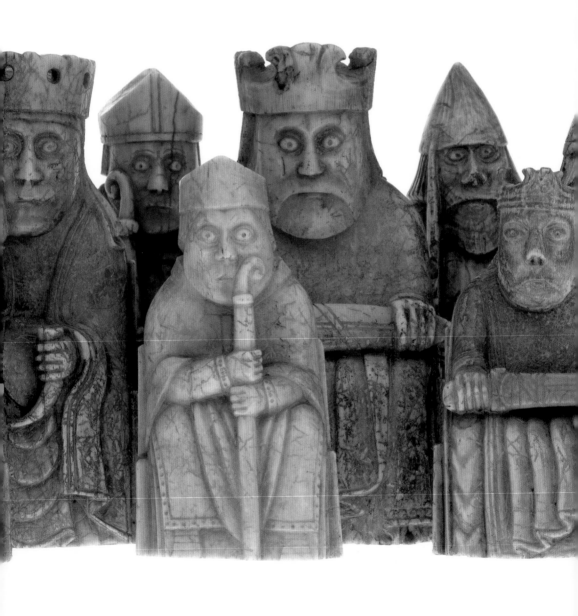

Analysing
the Chessmen

IMAGINING that the Lewis chessmen belonged to someone in Lewis opens up all sorts of other possibilities. A belief that the hoard was a merchant's stock implied that the chessmen were brand new when lost, and all from the same source. If the hoard belonged to a great man, then the pieces may have been of some age when buried and might be from more than one source. They might not all be the same date, and include pieces which are substitutes for ones lost or broken. A recent research project by the authors has considered these very issues.

So far no evidence for wear and tear on the pieces, consistent with them being used in gaming, has been detected. This is not surprising. Walrus ivory is a very tough substance and it would arguably take constant playing over many years for such wear to be observable.

Differences in the pieces resulting from the work of different craftsmen and workshops appears a much easier thing to trace, although there are obvious problems in trying to compare, say, a bishop with a warder, since they both have different clothing and equipment. This is why it is important to concentrate on the faces. The authors supposed that craftsmen carving chessmen, day in and day out, would tend to give them the same faces, in the same way as a cartoonist nowadays, or the carver of

holiday souvenirs. Grouping the face-pieces by their faces would clearly be a very subjective business if we relied solely on a visual examination. Instead, we have employed Caroline Wilkinson's skills as a forensic anthropologist to make a comparative study, assessing and comparing each face with the aid of magnification and measurements. The aim was to characterise and describe the different faces, sorting them into groups, principally by checking the proportions of mouths, noses and eyes, both vertically and horizontally.

It was possible to group 50 of the 59 face-pieces on this basis. The remaining nine were either too damaged and indistinct or too different from the identified groups to be included in any of them.

A long straight nose with a flat base, inferiorly placed nostrils and a high nasal root (between the eyes); round open eyes; a down-turned mouth; and a long naso-labial distance (the distance between the nose and the upper lip). Similarity in vertical and horizontal proportions between all the pieces. [Fig. 14]

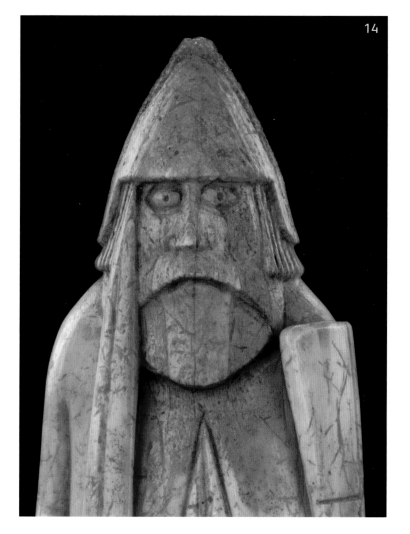

14

GROUP B

A bulbous nose with round alae (the fleshy part of the nose surrounding the nostrils) and visible nostrils; a wide short face; round open eyes; a down-turned mouth; a retrusive chin; and asymmetrical eye heights. Similarity in vertical proportions between all the pieces, but variations in horizontal proportions between them.
[Fig. 15]

National Museums Scotland bishop showing Group B face (NMS 26).

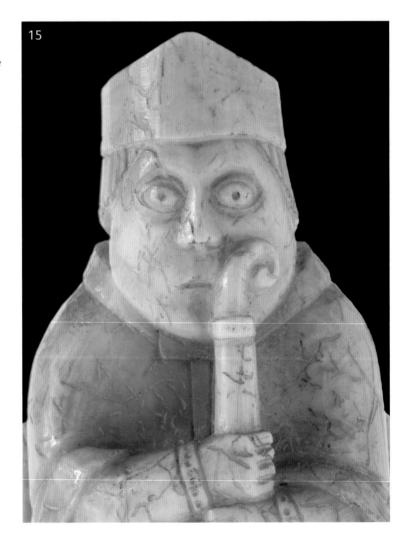

15

A long narrow nose with an up-turned base, flat alae and visible nostrils; round open eyes; a down-turned mouth; an infraorbital crease (crease below the eyes); a clear philtrum (column-like hollow between the nose and the upper lip); and an upright facial profile. Similarity in vertical proportions between all the pieces, but variations in horizontal proportions between them. [Fig. 16]

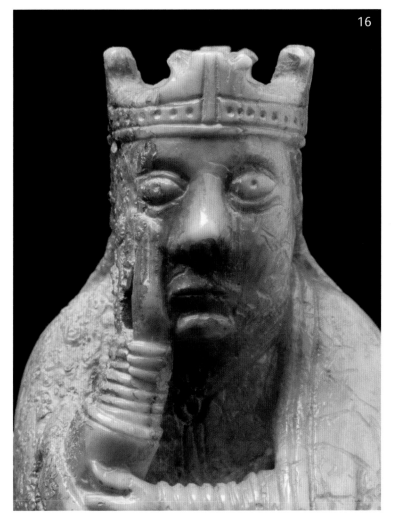

16

National Museums Scotland queen showing Group C face (NMS 22).

GROUP D

A wide short face; a straight nose with a rounded tip, round alae and visible nostrils; round open eyes; a down-turned mouth; an infraorbital crease; a clear philtrum; nasolabial creases; and an over-bite (malocclusion where the upper teeth are more prominent than the lower teeth). Similarity in vertical and horizontal proportions between all the pieces. [Fig. 17]

National Museums Scotland king showing Group D face (NMS 19).

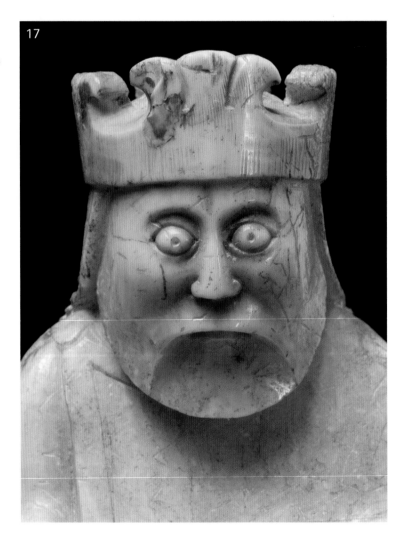

A defined nose with straight flat profile, visible nostrils and shaped nasal base; round open eyes; and an infraorbital crease. Similarity in vertical and horizontal proportions, except for the one bishop in the group. [Fig. 18].

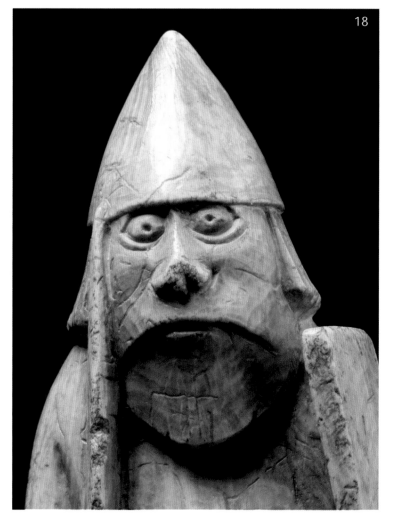

18

National Museums Scotland warder showing Group E face (NMS 28).

It is our contention that these groups represent the work of five different craftsmen. If we also grade the face-pieces by size to apportion them into four sets, we produce the following distribution pattern:

GROUPING OF LEWIS CHESSMEN BY GROUPS AND HEIGHT

	SET 1 (largest)	SET 2	SET 3	SET 4 (smallest)
Kings	AD	DX	BB	CX
Queens	CC	DD	BB	CX
Bishops	CDDD	CCDE	BCCC	BBBD
Knights	AAAX	AAAX	ACXX	BCC*
Warders	AA**	ADEX	BCCE	DX**

X = ungrouped pieces * = missing pieces

Since there are no clear divisions between our putative sets, this may be evidence that most of the chessmen were manufactured in the one workshop with four or more master craftsmen working on ivory chessmen at any one time. It is possible the workshop received a commission to make four chess sets, or that the same patron gave the workshop repeat orders over a period of several years.

The latter scenario might help to explain the range of design details in the individual pieces. Some things, like the bishops' mitres and the shields carried by the knights and warders, seem to reflect changing fashions over a period of time extending from the mid-twelfth century into the early thirteenth century. This does not mean that any of the pieces are necessarily as early as the mid-twelfth century, but it is difficult to avoid the conclusion that some are later than has hitherto been supposed. In the case

of the bishops, two with mitres with low sides, relatively high peaks and a peaked front bottom edge, would seem to belong in the early thirteenth century [Figs 4.26 and 4.30]. The same is true for those knights and warders with relatively narrow shields with a straight top edge [cf. Fig. 14].

At least two of the face-pieces which could not be grouped are particularly deserving of further consideration. One, a king [Fig. 4.7], assigned to Set 2, seems so different in the appearance and large size of its head that it can readily be imagined to be a piece from another workshop, perhaps even another centre of manufacture. The warder has a unique type of kettle-hat, carinated, and seemingly covered with cloth with diamond-shaped piercings [Fig. 4.55]. It is difficult to parallel, but broadly similar kettle-hats are depicted in the Morgan Picture Bible in the Morgan Library in New York. It is believed to have been produced in Paris in the 1240s.

This king and warder may well be replacements for missing or broken pieces. The warder may also be used as evidence for how long the chessmen remained in use before being hidden – certainly the 1240s, if not even later.

Another thing which is evident from a detailed study of the chessmen is that they are not all of the same quality of design and execution. The craftsman who carved the pieces with Group D faces (for instance, Fig. 4.4) was clearly a man of very consider-able artistic ability, producing chessmen which can be regarded as works of art. The crudest pieces, with grotesque faces and awkwardly executed clothing, were produced by the craftsman who did the Group C faces (for example, Fig. 4.58). In producing one of his bishops, the latter showed so little understanding of what he was representing that he carved him with a chasuble to one side of his crosier but not the other [Fig. 4.25].

There are other errors of execution which may be attributed to a busy workshop working under pressure to fulfil orders. These include a knight and a bishop whose hair has not been properly completed [Fig. 4.63], and a knight with a deep groove

in the neck of his horse caused by over-cutting when the piece was first blocked out.

The scarcity and value of walrus ivory is indicated by the evident desire not to waste any part of the tusks, which might have averaged about 400 to 500 millimetres in length. Walrus tusks have a dense hard outer layer of dentine and a core of less dense, sponge-like or granular dentine. The best results were achieved by carving all of the details of the chessmen in the outer dentine, and certainly the faces. In many of the pieces the division between outer and inner dentine can be clearly seen, the former appearing smooth and cream coloured, the latter rougher and darker. In Fig. 19, of a king, it can be seen that his face and throne are carved in the outer dentine, while most of the rest of his head and body are cut into the inner dentine.

Considerable skill was involved in getting the maximum number of chessmen out of a tusk, sometimes two pieces from one segment of a tusk. One of the queens [Fig. 20] has one side of her throne attached as a separate piece, probably by the original maker. This may demonstrate the lengths to which he was prepared to go to utilise an inconveniently small piece of tusk.

Not all the chessmen are made of ivory. At least three, including a warder in the collection of National Museums Scotland [Fig. 4.48] have been carved from whales' teeth which may have been regarded as a cheaper material.

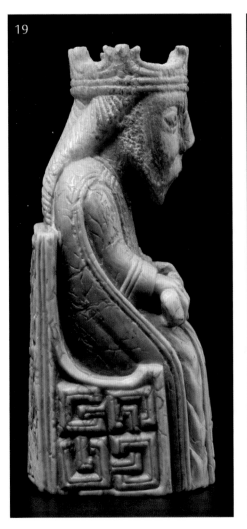

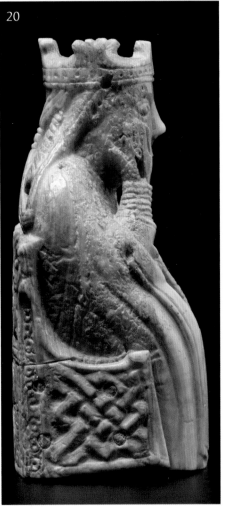

From Trondheim

GIVEN that Lewis was part of the Scandinavian world, and there were great men there who would have been patrons of art and recipients of prestigious gifts, should we consider the possibility that the chessmen were manufactured on that island?

As with so much from medieval times, no strong evidence survives to confirm or deny such a hypothesis. While many craftsmen were itinerant, most scholars would at present expect to locate the manufacture of such pieces in a town or large trading centre. The craftsmen who made such prestigious items were, perhaps, more likely to thrive in such a setting. Our detailed study of the Lewis chessmen demonstrates that they had a good understanding of the robes, vestments and protective clothing worn by kings, queens, bishops and knights. This surely suggests that they had access to such people, or were perhaps employed in workshops provided by a king or archbishop. Lewis had no towns at the time in question, but there were strong links between the Western Isles and major Norwegian towns, particularly Bergen, where the kings of Norway often held court, and Trondheim, another royal centre and the site of the archbishops' cathedral.

The limited evidence favours Trondheim over Bergen as the likely centre of manufacture of ivory chessmen. Apart from the

ivory queen already mentioned, excavations in the town have led to the recovery of a wooden king of similar form to the Lewis pieces. It is thought to date to the early thirteenth century. There is a piece of twelfth-century walrus-ivory carving, perhaps the head of a staff, from the island of Munkholmen, near Trondheim. Its scrollwork decoration is comparable to that on some of the Lewis chessmen. It is known that by the early fourteenth century, and possibly much earlier, the Norse settlers in Greenland paid the archbishops large quantities of walrus tusks as tithes (taxes). A king, made from a whale's tooth, has recently been found on the island of Hitra to the west of Trondheim. It is in the same tradition as the Lewis kings, but is clearly later, perhaps late thirteenth or fourteenth century in date.

The Lewis chessmen bishops are the earliest chess bishops known. In earlier versions of the game, the positions occupied by bishops were taken by elephants. Could it be that this substitution reflects the interest and patronage of a senior cleric like an archbishop of Trondheim? None of this makes it certain that Trondheim was the place many or all of the Lewis chessmen were made, but it is at least a strong probability.

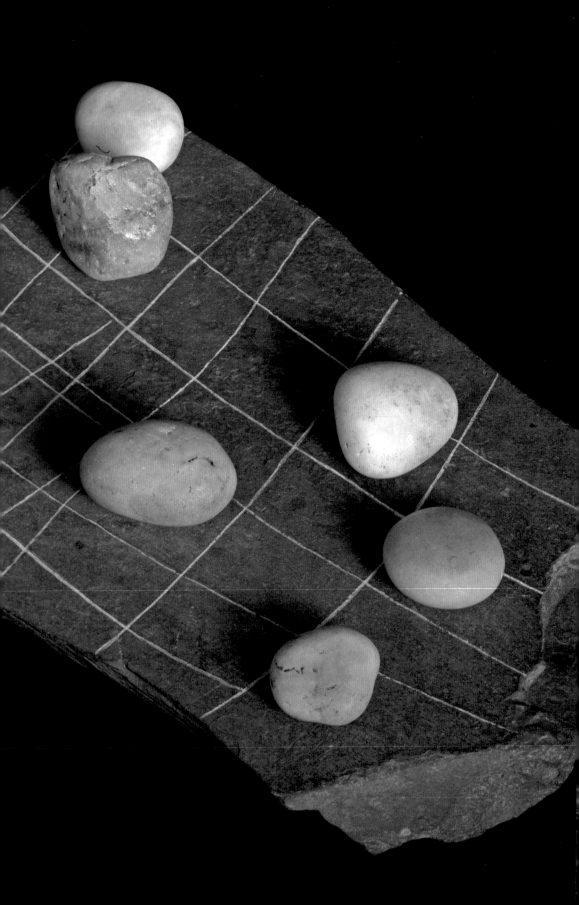

Playing Games

CHESS may have been relatively new to Lewis in the late twelfth century. The origins of the game probably lie in India in, or prior to, the sixth century AD. From there it spread westwards and was widely known in Europe by the eleventh century. The earliest European chessmen copy Islamic models, being non-figurative or abstract. The Lewis chessmen are among the earliest that are shaped as recognisable figures. They are also among the earliest chessmen from the area that is now Scotland.

The game of chess has also evolved considerably over the centuries. Earlier versions had ministers or vizirs instead of queens, war elephants instead of bishops, and chariots instead of rooks. The composition of the Lewis chess sets – with a king and queen, bishops, knights, warders and pawns – is clearly much more relevant to the make-up of Scandinavian society in the twelfth and thirteenth centuries. The pawns represent the common folk, or at least those men who were obliged to do military service. The warders – the term for these pieces coined in 1832 by Frederic Madden, Assistant Keeper of Manuscripts in the British Museum – represented a more élite group of warriors, but ones not of the same high status as knights or nobles. These were (royal) retainers or mercenaries.

Chess was not the only board game that required kings and

Opposite:

21. JARLSHOF GAMING-BOARD

Fragment of a double-sided slate game-board (X.HSA 801 and 778) from the Viking age settlement at Jarlshof, Shetland. One side appears to have been for playing hnefatafl.

pawns. There was another game called *hnefatafl*, in which one player had a group of attackers arranged around the edge of the board and attempted to capture a centrally-placed king defended by his guards. The player with the king could win if he could get his king to one of the four corner squares.

Hnefatafl was already popular in the Scandinavian world prior to the advent of chess, and, as time went on, more and more turned to playing chess and hnefatafl became a minority interest or disappeared altogether. There is evidence of hnefatafl having been played in Orkney in the Viking age, in the form of game-boards, and there is one from the Viking settlement at Jarlshof in Shetland [Fig. 21]. It is crudely carved on a piece of slate. Both sides are chequered, one side with the central area in a circle and five of its squares marked with a cross. This would have been for positioning the king and four men to guard him. A hnefatafl board, incised in stone, from a thirteenth-century context at Whithorn Priory (Dumfries and Galloway) in Scotland, provides evidence that the game continued to be played at that time.

The 14 plain ivory disks [Fig. 4.61] found with the Lewis chessmen are often forgotten about, but they are important evidence that the hoard was not just for playing chess. These disks are best interpreted as tables-men. Many other medieval tables-men are known from Europe, mostly decorated and of smaller size. There is an eleventh-century bone and antler set with a board from Gloucester Castle in England, and others of eleventh to twelfth-century date from St Margaret's Inch (Angus) [Fig. 22] and St Andrews (Fife), both in Scotland.

These tables-men were for playing a board game – tables – a forerunner of modern backgammon. Tables already had a long history, extending back for hundreds of years, by the time the pieces in the Lewis hoard were carved. Board games were widely played in the ancient world and there is evidence for them in Scotland from the Iron Age onwards.

It is possible that the Lewis hoard represents the remains of a

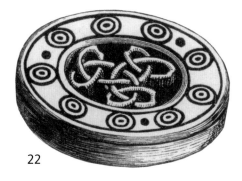

22. TABLES-MAN

A tables-man of 11th-
to 12th-century date
from St Margaret's
Inch, a crannog in the
Loch of Forfar, Angus.

games compendium designed for playing chess, hnefatafl and
tables. What we regard as chess kings could have doubled for use
in hnefatafl, along with either some pawns or warders. Indeed, it
is an intriguing possibility that the craftsmen who made these
pieces may deliberately have chosen warders to substitute the
chariots prevalent in earlier sets precisely because they could
more conveniently double for the pawns or guards of hnefatafl.
Early game-boards that are two-sided – one for hnefatafl, the
other for another game like tables or merels – are reasonably
common in the Scandinavian world. Double-sided game-
boards have been with us ever since and there would no doubt
have been many in the twelfth and thirteenth centuries that
combined chess and hnefatafl, like apparently the board from
Greenland, made of walrus ivory or whales' teeth, given as a
present to Harald Hardrada, an eleventh-century King of
Norway. The source for this is the Icelandic Króka-Refs Saga,
an early fourteenth-century story of doubtful historicity. There
are no clues as to whether or not the Lewis hoard was buried
with one or more board. If, as would have been likely, such
boards were of wood, they would not have survived in the
ground for hundreds of years.

The playing of board games was popular in both medieval
Scandinavian and Gaelic society. Kali Kolsson, prior to becom-
ing Earl of Orkney in 1129 and changing his name to Rognvald,
made a poem listing the nine key skills or attributes of a noble-
man. The one that headed his list was ability at playing 'tafl',

which may have been understood to include a variety of games like chess and hnefatafl. This idea that playing games well was a mark of a great man crops up in Gaelic poetry as late as the eighteenth century. And women clearly played as well from early days. That the game was not just the preserve of nobles is demonstrated by the legend of Tristan, in a version recorded as early as 1200. It has Tristan taking ship with Norwegian merchants who have a chess-board on which Tristan plays.

The continuing interest in playing board games in the Western Isles can be demonstrated by the discovery of other tables-men dating to medieval times. From Iona Abbey there is a fifteenth-century bone piece carved with a crowned mermaid grasping her tail with one hand, and holding a fish with the other [Fig. 23]. Another bone tables-man found in a cave on the Isle of Rúm is decorated all over with an interlace design [Fig. 24]. Two decorated bone tables-men, as well as about 50 plain counters or tables-men of stone, have been recovered from the excavations at Finlaggan, the home of the MacDonalds on Islay.

In 1782 Lord MacDonald gave the museum of the Society of Antiquaries of Scotland the handle of an ancient dirk. It was only later that it was realised that this was in fact a very fine chessman (rook?) of walrus ivory, dating to the mid-thirteenth century, with two warriors, back to back in a framework of foliage scroll-work. Both are clad in mail hauberks and have drawn swords and shields [Fig. 25]. Its place of manufacture is unknown – possibly in Scandinavia or Britain. And it may have been recovered from Loch St Columba in Skye, which contained an island residence of the Kings of the Isles.

Not from the Isles themselves, but from the castle of Dunstaffnage on the west coast of Argyll near Oban, is a chess king made from a sperm whale's tooth [Fig. 26]. The present whereabouts of this piece are unknown, but on the basis of an early nineteenth-century drawing, it can on stylistic grounds be dated to the late fifteenth or early sixteenth century. It is, however, very much still in the same tradition as the Lewis chessmen.

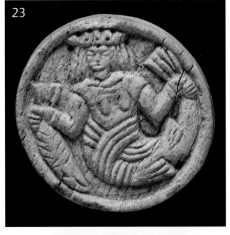

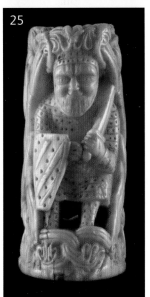

23 AND 24. TABLES-MEN

Bone tables-man (23) (NMS H.NS 99) from the Isle of Rum, *c.*1500, and (24) (NMS H.NS 92) of 15th-century date from Iona abbey.

25. CHESS ROOK(?)

Made of walrus ivory, mid-13th century, possibly from Isle of Skye (NMS, H.NS 15).

26. CHESS KING

Made from the tooth of a sperm whale in the late 15th or early 16th century, this piece was discovered at Dunstaffnage Castle near Oban, Argyll. From an early 19th-century drawing.

All this reinforces our contention that the presence of the Lewis chessmen on Lewis should not be seen as some aberration, resulting from their loss in transit elsewhere.

Their loss must be viewed as accidental, but not unreasonably a matter involving an owner who lived on or frequented Lewis, failing to recover this treasure which he had temporarily hidden for safe-keeping.

The Legacy

AS works of art, the Lewis chessmen tell us a great deal about the Scandinavian world in the twelfth and thirteenth centuries, what people valued and the quality of life. They are a useful source of information on how royalty, clerics, knights and warriors dressed. They have fascinated hundreds of thousands of people worldwide since their discovery and their popularity appears to be going from strength to strength. The replica chessmen and images of them that are widely available are a testimony to this, as is their use in advertising. Indeed, they often crop up in the most surprising and unusual situations. Here we draw attention to some of their appearances in literature, films and on televisions.

Two films set in the twelfth century – 'Becket' (United Kingdom 1964) and 'The Lion in Winter' (UK 1968) – feature Lewis-style chess sets being played, in the former by King Louis of France and one of his noblemen, and in the latter by King Philip II of France and Geoffrey, the son of King Henry II of England. More recently they are the inspiration for the chessmen in the film of J. K. Rowling's 'Harry Potter and the Philosopher's Stone' (United States 2001).

That doyenne of children's literature, Rosemary Sutcliff, wrote her *Chess-Dream in a Garden* around the Lewis chessmen, and

on television, and subsequently in book form, they inspired the classic children's animation, 'The Saga of Noggin the Nog', as described by one of its creators, Oliver Postgate:*

> At different times both Peter Firmin and I had visited the … Museum, where we had both noticed a set of Norse chessmen from the island of Lewis. What had impressed us was that, far from being fierce and warlike, it was clear that these were essentially kindly, non-belligerent characters, who were thoroughly dismayed by the prospect of contest. … it occurred to Peter that the chessmen … could well have been called Nogs, that their prince was a Noggin and that the wicked baron … could be their … uncle, perhaps a Nogbad.

The creators of Noggin the Nog realised that there was a lot to be made of the faces of the Lewis chessmen, that children as well as adults could empathise with them. As we hope that this account has shown, it is the faces, the individuality of the pieces, that continue to fascinate, and which probably still have a lot to tell us.

* O. Postgate: *Seeing Things, An Autobiography* (London: Methuen, 2000), pp. 219-20. Used with the kind permission of Daniel Postgate.

References
and Research

THE research on which this book is based has already been published as:

Caldwell, D. H., Hall, M. A. and C. M. Wilkinson (2009): 'The Lewis Hoard of Gaming Pieces; A Re-examination of their Context, Meanings, Discovery and Manufacture', *Medieval Archaeology* 53 (2009), 155-203. More detailed arguments are presented there for our conclusions, and also sources for our information and assertions.

Readers may also like to read the following:

Hall, M. A. (2007): *Playtime in Pictland: The Material Culture of Gaming in Early Medieval Scotland* (Rosemarkie: Groam House).

Hamilton, J. R. C. (1956): *Excavations at Jarlshof, Shetland* (Edinburgh: HMSO), 76, and pl. xiiib.

Macdonald, N. (1975): *The Morrison Manuscript. Traditions of the Western Isles by Donald Morrison, Cooper* (Stornoway: Public Library).

McDonald, R. A. (1997): *The Kingdom of the Isles. Scotland's Western Seaboard, c.1100-c.1336* (East Linton: Tuckwell Press).

McLees, C. (2009): 'A carved medieval chess king found on the island of Hitra, near Trondheim, Norway', *Medieval Archaeology* 53, 315-21.

Murray, H. J. R. (1913): *A History of Chess* (Oxford: Oxford University Press).

Postgate, O. (2000): *Seeing Things, An Autobiography* (London: Methuen), 219-20.

Robinson, J. (2007): *The Lewis Chessmen* (London: The British Museum Press).

About the Authors

Dr David H Caldwell is Keeper of Scotland and Europe for National Museums Scotland. He has been privileged to be the curator responsible for the eleven chessmen in Edinburgh for the last 37 years and has long been fascinated by them. His other research interests include the history and archaeology of the Western Isles in medieval times, and in the 1990s he directed major excavations at Finlaggan, in the Island of Islay. He has recently had published a history of Islay – *Islay The Land of the Lordship* (Edinburgh: Birlinn, 2008).

Mark A. Hall is History Officer at Perth Museum & Art Gallery, where he curates the archaeology collection. He has long-standing interests in medieval material culture (in which the recognised collections of Perth are very rich), including Pictish sculpture, the cult of saints and play, especially board and dice games, in part stemming from a long-standing fascination with the Lewis chessmen. His interest in play culture extends to research on the way the medieval period (and archaeology more generally) is portrayed in cinema.

Dr Caroline M. Wilkinson is Senior Lecturer in Forensic Anthropology at the Centre for Anatomy & Human Identification, University of Dundee. She is an expert in faces and craniofacial identification and her research focuses on the relationship between the soft and hard tissues of the face, juvenile faces, facial recognition, anthropometry and facial image analysis. She has carried out craniofacial analysis for many archaeological investigations and her work is exhibited in museums around the world and is included on television programmes such as 'History Cold Case' (BBC), 'Meet the Ancestors' (BBC), 'Secrets of the Dead' (C4) and 'Mummies Unwrapped' (Discovery).

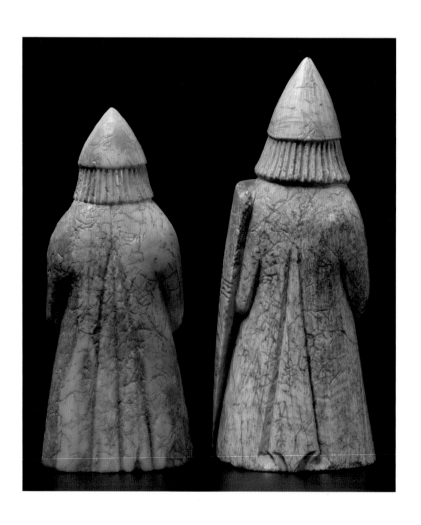